It's a GIRL THING

It's a GIRL Thing

More than 300 Qualities, Quirks, & Quibbles
That Uniquely Define Women

• • •

TOMIMA EDMARK

TOWLEHOUSE PUBLISHING

Nashville, Tennessee

TowleHouse books are distributed by National Book Network (NBN), 4720 Boston Way, Lanham, Maryland 20706.

Cataloging-in-Publication data is available.
ISBN: 0-9668774-6-2

Cover and page design by Gore Studio, Inc.
Inside illustrations by Mike Harris

Printed in the United States of America
1 2 3 4 5 6 — 05 04 03 02 01

Contents

Introduction

Men don't understand it, and women can't explain it...or don't want to. It's the thing a woman does or says that seems to have no logical interpretation or rational thought pattern. You know what I'm talking about: buying another pair of black shoes when she already has ten, crying when the argument seems to be turning in his favor, or gallantly turning down dessert only to eat his.

Many a man, when first confronted by such an act, has thought to himself that some reasonable explanation had to exist. But, after a relentless investigation, no rational answer ever seems to present itself. Defeated, most men simply retire to the sofa and grab the TV remote, muttering under their breath the distinctive four-word phrase, "It's a girl thing."

This book is a collection of girl things. That's all. Pure and simple. And no explanations will be given. After all, the explanation is implicit in this book's title: It's a girl thing.

In Love
and War

Sending loud signals to a guy to make the first move, only to rebuff him when he finally does.

Having money atop her list of marital qualities in a potential partner.

Immediately labeling any girl being nice to her boyfriend as a slut.

Wanting a permanent commitment from him after their first kiss.

Being of the opinion that now is the
ideal age for her to marry.

Bragging about the capture and
taming of her significant other.

Philosophizing that guys, unlike
government bonds, never mature.

Thoroughly enjoying a man
who acts jealous.

Swooning over any
gallant gesture.

Having sex is akin to
giving a dog a bone
for good behavior.

Knowing if it has tires or testosterone, it will eventually let her down.

Saying she wants a sensitive guy while dreaming about an insensitive guy.

Thinking in sixes—commitment after six dates, engagement after six months, etc.

Immediately solidifying her new last name on monogrammed sheets and towels.

Thinking her date's only goal for the
evening is to get into her jeans.
(She is not wrong.)

Hoping he'll call after their torrid first
date—even though it was more
than a month ago.

Pointing to a pretty woman while
asking him if he thinks she's pretty,
and then becoming agitated if
he tells the truth.

Thwarting off any future physical contact with a guy by saying, "Let's just be friends."

Running around canvassing friends and perfect strangers for their advice on your relationship.

Dismissing the thought that men may not like sharing a bedroom decorated in pink with ruffles and lace.

Quietly despising anyone who doesn't find her baby absolutely adorable.

Woefully complaining during pregnancy and childbirth . . . but willing to go through it all again a year later.

Refusing to type on a computer all day because she wants to save her nails for her date that night.

GIRL REASONS FOR SAYING "NO"

1. "I have to get up early."

2. "I'm sunburned."

3. "It's too hot."

4. "I'm already asleep."

5. "I don't want to muss my hair."

6. "I have a headache."

7. "The neighbors will hear us."

8. "You'll wake the baby."

9. "I'm not in the mood."

10. "I'm too tired."

Letting him have the aisle seat
whether it's at church, at the movies,
or on an airplane.

Having her week made by the news
that Tom Cruise is getting divorced and
is therefore "available" again.

Owning numerous pieces of sexy
lingerie but still too modest to wear
them when alone with him
in the bedroom.

Referencing the "ex-boyfriend" in mythical terms when her current partner is not doing what she wants.

Blaming her singleness on the fact that the good ones are taken and what's left are substandard.

Not understanding that taking a quiz together will inevitably result in an argument.

Comparing every wedding to her own.

Choosing the frog over the prince if he has money.

Using mysterious gynecological disorders as excuses.

Wanting to know about *all* the previous women in his life.

Secretly being disappointed when he
remembers their anniversary.

Comparing the man in her life to
her pedestal-elevated father.

Thinking about "the Relationship"
all the time.

Finding his mind not only wanders
but frequently leaves.

Not complaining when he suggests Home Depot for their Date Night destination.

Health and Beauty

Believing the more time she spends
getting ready, the prettier
she will become.

Spending hours in the pursuit of
the proper eye shadow color to
coordinate with her handbag,
shoes, and panty hose.

Not eating for a week in order
to save up enough money for
her hair appointment.

Judging the quality of her haircut by the number of people who notice.

Gallantly passing on dessert, only to mooch a bite from someone else's.

Transforming her car's dashboard into her mobile dressing table.

Selecting a car based on one feature—the vanity mirror.

Crimping her eyelashes and thinking they still look natural.

Eating what's fast, cheap, and easy, while prophesying, "We are what we eat."

Finding joy in the fact that every seven minutes someone pulls a hamstring in an aerobics class.

Finally getting her head together only to find her body starting to fall apart.

Plucking out her eyebrow hairs, only to turn around and draw them back in with an eyebrow pencil.

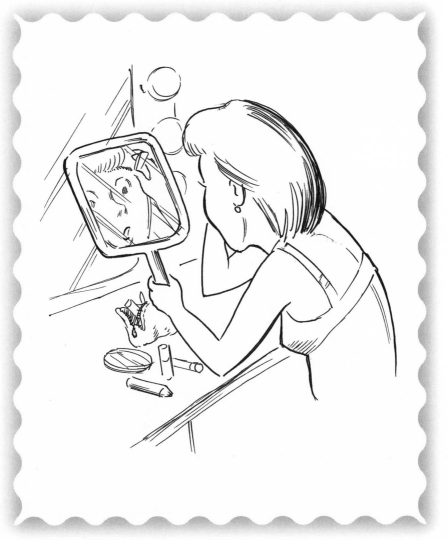

Concluding long hair makes
her look thinner.

Knowing all bathroom scales are
off—and never in her favor.

Justifying chin hairs as
really stray eyebrows.

Seeing the bottom of an
ibuprofen bottle in just one day.

Using mayonnaise as a hair and scalp moisturizer.

Possessing the uncanny ability to use anything reflective as a vanity mirror.

Popping a bag of popcorn for a midnight snack when she can't sleep.

Considering a long-term relationship with collagen.

Dreading the thought of having
"pancake boobs" at her
annual mammogram.

Exorcising the words *lump*, *blemish*,
and *cellulite* from her vocabulary.

Knowing that Gore-Tex does not refer
to the 2000 presidential race.

Days ending in "y" tend to be her bad-hair days.

Obsessing over her breasts, hips, thighs, and upper arms.

Never going a day without thinking about implants.

Owning twelve red lipsticks yet needing one more because all the others are the wrong shade.

Willing to smear anything on her face if it claims to reduce wrinkles or make her look younger.

Striving to look like one of the only eight known supermodels.

Always keeping an eye out for
a suitable support group.

Finding a soulmate in
Richard Simmons.

Acquiring an encyclopedic knowledge
of the hundreds of items offered at
the local health-food store.

• GIRL FOOD •

1. Water

2. Chocolate

3. Rice cakes

4. Sunflower seeds

5. Salads

6. Anything white

7. Yogurt

8. Anything "lite"

9. Anything "low fat"

10. Anything "diet"

Gorging on calories every now and then, but only when alone.

Feeling her stress level creep up the closer she gets to an upcoming appointment with her gynecologist.

Being a good girl all day long when it comes to her diet then chucking it all for a late-night batch of Toll House cookies.

Dreading hormonal
moustaches.

Finding beauty in the
birthing process.

Going all out to prepare
a scrumptious feast for
everyone else, then sitting
down with them to nibble
on a dressing-free salad herself.

Pumping iron in the gym like
a pro, but cooling it just
enough so her arms and legs
don't get bigger and better
defined than his.

Asking friends and family for their opinion on the size of her behind, only to get upset when the answer is anything other than petite.

Admiring the wafer-thin likes of Courteney Cox, Calista Flockhart, and Lara Flynn Boyle even when well aware of the health hazards.

Changing hairstyles quarterly.

Taking any beauty tip as gospel.

Pulling, waxing, plucking, or shaving hairs around her groin all in the name of a better bikini line—even though she wouldn't be caught dead in a bikini.

Designating her bathroom as "off-limits" to everyone else.

Calling in sick at work in order to make a hair appointment.

Leaving her hair all over the bath-room.

Thinking about how "fresh" she feels.

Working her way through jazzercise, water aerobics, spinning, Tae-Bo, and every other fitness trend de jour.

Clothes and Shopping

Dressing herself in sexy lingerie,
convinced he will somehow transform
into one of those soap opera hunks.

Convulsing at the sight of another
woman wearing the same outfit.

Hiding shopping-spree purchases
in the trunk of her car.

Paying ridiculous prices for underwear and bathing suits.

Needing to leave the office and go home after discovering she has panty lines.

Knowing with certainty that wearing shoulder pads makes her look thinner.

Convincing her spouse that food costs
have tripled in the last year.

Wondering why the sport of shopping
hasn't made it to the Olympics yet. She
feels she could be a contender.

Feeling like a kid in a candy store
during her occasional forays
to rural outlet malls.

Having "strap" problems in public.

Knowing her jeans are smaller because the dryer shrunk them.

Asking her guy (who owns only three pairs of shoes) to help her select the correct pair from her vast collection.

Looking at spandex as her best friend or worst enemy, depending on what kind of shape she's in.

Carrying a purse in which the pieces of price-club, debit, and grocery plastic now outnumber her credit cards.

Noticing in minute detail what the most attractive girl at a party is wearing, then providing enough negative commentary to fill the length of the ride home.

Monitoring QVC and the Home Shopping Network by using the PIP (picture-in-picture) feature on her TV.

Taking her time backing out of a parking space after noticing someone is waiting for her spot.

Throwing out his favorite clothes without asking permission, rationalized by "being in his best interest."

Posing like a flamingo in front of her mirror, trying to decide which shoes to wear.

Finding nothing wrong with Amelda Marcos's shoe collection.

Grabbing a shopping cart gives her ownership of "the road."

Carving out a spot in the household budget for "emergency" uses and then tapping into it for Tupperware.

Being sure to spend all three hundred dollars in her purse on clothes, whether she's shopping at Saks or "saving" money at a consignment store.

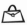

Picking out new clothes and paying for them knowing that she will return at least half of them after trying everything on a second or third time at home.

Getting the best of both worlds while shopping at one of those upscale lingerie stores, because she loves the selections and it's one time that her guy looks forward to shopping with her.

· GIRL FASHION FAUX PAS ·

1. Belt, shoes, purse not matching
2. Chipped nail in public
3. Visible panty lines (vpl)
4. Bra strap showing on shoulder
5. Socks with sandals
6. Visible "roots"
7. Leg hair
8. Cutoffs at workout gym
9. Mascara running
10. Short skirt with fat legs

Hating to buy a new car.

Wearing his clothes.

Buying additional pairs of shoes she doesn't need because they were on sale.

Owning "fat clothes."

Having hundreds of
clothing choices,
yet proclaiming she
has "nothing to wear."

Girls Just Want to Have Fun

Insisting on buying a Big Gulp after each pit stop made on a road trip.

Inviting other girls to join her when she needs to go to the ladies' room.

Carrying on a single conversation with another girl and being able to cover a minimum of two thousand topics.

Owning a little fluffy, yipping dog
and carrying it around in a purse.

Refusing to believe she is anything
but the superior mommy.

Being automatically attracted to a guy
who owns a boat twenty feet or longer.

Hearing only what she
wants to hear.

Seeing only what she
wants to see.

Finding everything he
doesn't want her to find.

Being predisposed
to being late.

Knowing blondes really
do have more fun.

Screaming in public
when she sees a friend.

Sharing with other girls things most guys wouldn't confess to their barber.

Bringing home a new car, then promptly forgetting about it.

Lying about her age and thinking others buy into it.

Eating someone else's dessert means she's not taking in any calories.

• GIRL SUBSTANCES •

1. Mousse
2. Mascara
3. Wax
4. Conditioner
5. Scented soaps
6. Lotions
7. Anything with alpha hydroxy
8. Foundation
9. Gloss
10. Baby powder

Painting walls and hanging curtains
is fun—cleaning walls and
ironing curtains isn't.

Never forgetting that diamonds
are a girl's best friend.

Declaring to have excellent
communication skills because she
can spend hours on the telephone.

Averting her eyes when catching a glimpse of a man in a Speedo.

Adding fly-fishing to her repertoire of outdoor activities if it scores points with him.

Wishing she could look like Julia Roberts, sing like Celine Dion, and bag money like Martha Stewart.

Knowing she can read minds.

Telling her best friend everything.

Reading her favorite
book—her checkbook.

Wanting to know all the details.

Becoming energized by the act of gab.

Finding any excuse to add
chocolate chips to a recipe.

Wondering whatever happened
to Susan Powter.

Secretly trying on her wedding dress
once a year to see if it still fits.

Collecting cookbooks by the dozens.

Collecting retail catalogs by the dozens.

Collecting store coupons
by the hundreds.

Collecting criticisms by the thousands.

• GIRL PHRASES AND THEIR MEANINGS •

1. "We need" = "I want"
2. "It's your decision" = "It'd better be what I want"
3. "We need to talk" = "I need to complain"
4. "I'll be ready in a minute" = "Give me twenty minutes"
5. "Yes" = "No"
6. "No" = "No"
7. "Maybe" = "No"
8. "I'm not upset" = "I'm ticked"
9. "I can't" = "I won't"
10. "That's OK" = "That's not OK"

Simultaneously admiring and despising Britney Spears for being everything she had wanted to be as a teenager.

Claiming to be a Mary Ann fan but longing to be a Ginger.

Spending more time behind the wheel looking at the passenger beside her than at the road.

Having the amazing capacity to be oblivious to the smell when putting on fingernail polish.

Putting on a solo vocal performance in the shower that would knock 'em dead at any karaoke contest.

Carrying two cell phones—one for personal use and the other for professional.

Hoping against hope that Barbra Streisand will perform in concert just one more time.

Taking ten minutes to set up the perfect "candid" Polaroid shot.

·GIRLS' FAVORITE GUYS·

1. Fabio
2. Ricky Martin
3. Tom Cruise
4. Julio Iglesias
5. Her hairdresser
6. Frank Sinatra
7. Denzel Washington
8. Fabian
9. Jeff Gordon
10. Dad

Having a private stash of videos that starts with *The Bridges of Madison County, Gone With the Wind,* and *Terms of Endearment.*

Going to a ballgame and by the fifth inning knowing the idiosyncrasies of everyone else sitting within two rows of her, yet not caring what the score is or even who's playing.

Keep It Simple, Stupid (KISS)

Agreeing to a camping trip as long as
there's indoor plumbing and a plug
for her hair dryer.

Writing checks and/or charging
amounts of under ten dollars.

Requesting that directions be given
using only the terms *left* and *right*.

Rejecting the idea that the flashing
12:00 on her VCR should have any
meaning other than to light
her way to the buttons.

Putting a decision that will impact
the future of her family in
the hands of a psychic.

Waiting in line at a toll booth,
only to not have her money
ready when it's her turn.

Not having the ability to correctly calculate driving distances. What she thinks is five miles is actually fifteen.

Willing to tune into one TV channel for the rest of her life.

Explaining to her mom that "Internet" isn't actually a new hair spray.

Hiding her fine jewelry in a very safe
place, only to forget where she put it.

Shrugging off any suggestion that she
can ever be too thin or too rich.

Being offended by a young,
beautiful girl who's braless.

Deeming logic and accountability in an argument as trivial.

Paying the monthly car payment is the true car sickness.

Getting along with other females in her family requires taking Prozac.

Preferring rich chocolate, rich coffee, and rich men.

Being lied to by auto mechanics.

Obsessing over a clean house.

Not knowing or caring what
fourth-and-ten means.

Being a groupie.

• GIRL MOVIES •

1. *Love Story*

2. *When Harry Met Sally*

3. *Nine to Five*

4. *Thelma and Louise*

5. *Sleepless in Seattle*

6. *Dr. Zhivago*

7. *Pillow Talk*

8. *Pretty Woman*

9. *Sabrina*

10. *Working Girl*

Not using her turn signal. She
knows where she's going;
so should everyone else.

Declaring an accurate age is important
only for wine and cheese.

Not bothering to check the oil:
She knows it's still there.

Always doing it right the first
time . . . in her mind, that is.

Asking you to call her back so she can switch on the answering machine.

Having to stop and think which way to turn a nut on a bolt.

Being robbed blind by dry cleaners and hairstylists.

Having the right to remain silent, yet rarely exercising it.

Driving a car and being totally oblivious to the fact that it has a flat tire.

Guessing that a taxidermist
is a fleshy taxi driver.

Not believing her car's gas gauge
when it reads "Empty."

Believing horoscopes.

Fueling up with coffee.

Always wanting the closest possible
parking spot so she can get home
quicker to crank out three miles
on her treadmill.

Entering the Super Bowl office pool
and picking the winning team based on
whose quarterback is cuter and picking
the points based on the ages
of her last two dates.

Greeting a girlfriend then breaking into a back-and-forth litany of compliments: "Oh! You've lost weight." "Yes, and your new haircut looks fabulous." "Thank you. And I must say, you did a great job matching your eye shadow with your earrings."

(Man)ipulator

Disliking a "macho" man, except
when a dead mouse needs to
be taken to the garbage.

Relentlessly looking to "catch" a guy
doing something wrong.

Enjoying the relentless analysis
of his shortcomings.

Asking for a guy's opinion on her clothing selection after telling him moments earlier all his taste is in his mouth.

Answering the question, "Is something bothering you?" with a "No," then becoming upset that he believed her answer.

Insisting a guy participate in the losing game of, "Do you notice anything different?"

Thinking she can change him . . . and she'll go to her grave trying.

Pleading with him to go shopping with her, then complaining the whole time about what a mistake it was for him to come.

Playing with his self-confidence by offering to "*pencil* in" their date on her calendar.

Assigning the duties of bug killer, mouse exterminator, and critter annihilator to her guy with the instruction of "Oh, but don't kill them."

Sounding a battle cry with the words, "Do I look fat in this dress?"

Making him feel bad for acting "macho."

Giving accolades to a guy for the slightest act of thoughtfulness.

Being safe in the knowledge that her guy is always thinking about her.

Offering to go "Dutch" but then never wanting to see him again if he takes her up on it.

Crying the moment it becomes apparent that she's losing the argument.

Waiting until he is in bed and almost asleep to ask him if he's locked the front door and turned off all the lights.

Preferring hints to straight talk.

Strategically timed headaches.

Remembering until her death things
he said in an argument.

Asking him to do something, then
telling him how to do it.

Looking interested.

Wanting to be missed even though
she never goes away.

Nagging about instead of just
taking out the garbage.

Lifting of more than five pounds
requires a man's touch.

Wearing a wonderbra with a low-cut neckline, then complaining that he's only looking at her chest.

Giving him three locations to keep his stuff: the attic, basement, and garage.

Giving him a detailed update of what he missed during his bathroom break, unless it was a sporting event.

Letting him win at H-O-R-S-E even
if he's a basketball stiff.

Concluding that the only man she can
really change is one wearing diapers.

Apologizing to him for the fifth
time after outdriving him
during a round of golf.

· GIRL QUESTIONS ·

1. "Do you love me?"
2. "Do I look fat?"
3. "What are you thinking?"
4. "What would you do if I died?"
5. "Do you think she's prettier than me?"
6. "Where are we going?"
7. "How do you like my hair?"
8. "Can we talk?"
9. "What'd you guys talk about?"
10. "Is that your final answer?"

Memorizing NASCAR trivia so she can give her guy a topic they both can discuss.

Giving her opinion or side of the story first and then declaring the discussion over.

Stating that she really doesn't want anything for her birthday . . . and then having a fit if he doesn't get her something.

Winning the dash to the mailbox
when both are expecting the
latest L. L. Bean catalog.

Beating him to the mailbox so she can
toss the *Sports Illustrated* swimsuit
issue before he sees it.

Beating him to the mailbox around
the day that her credit card bill
is due to arrive.

Incessantly complaining, then
wondering why he's ignoring her.

Hearing the truth and dismissing it
because it doesn't make sense.

Not ordering anything other than
a drink at the drive-thru, then eating
half his burger and fries as they
drive down the road.

Always getting the last word
in with him.

Ragging on her guy.

Avoiding logic like the plague.

Knowing the man who is right for her
is the one who can afford her.

Demanding to know every word spoken in a conversation her guy had with a pal.

Working the mention of Valentine's Day into every conversation after January 15.

Pointing out every spot he missed while mopping the floor, vacuuming the house, or mowing the yard.

Being a master at getting him to do anything she wants and making him think it was his idea.

Moody River

She doesn't have PMS: Everyone
around her has an attitude problem.

Clicking through channels and stopping
when she sees someone crying.

Finding all of his things unacceptable
for their new place together.

Being distracted from lovemaking if she knows dirty dishes are in the sink.

Hanging guest towels in the guest bathroom, only to become upset when someone actually uses them.

Feeling guilty, depressed, and inadequate while flipping through a fashion magazine.

Having her entire day ruined
by a broken nail.

Being catty.

Endlessly struggling through the
frustrations, challenges, and
setbacks until she finally
finds a hairstyle she likes.

Equating a bad mood with not eating.

Relinquishing to coworkers
the power to make her cry.

Consuming chocolate to solve a problem.

Not being "in the mood" when
her parents are in the house.

Finding someone else to blame
when something goes wrong.

Wishing to be a year older only when she is expecting a baby.

Having a mood swing every six minutes and being able to justify it.

Having an attitude and knowing how to use it.

Crying and crying and crying with her girlfriends.

Changing the thermostat twelve times in one afternoon.

Expressing anger while not showing it.

Loathing PMS at the same time she embraces the sympathy it elicits.

Stocking a different flavor of tea for every mood or malady conceivable.

Rearranging the furniture in the family room three times in one week.

Cleaning out or rearranging a closet at
1:00 A.M. because she can't sleep.

Unloading the dishwasher at 3:00 A.M.
because she still can't sleep.

Doing her laundry at 5:00 A.M. so
she can have something to
wear to work that day.

Asking "And your point is?" after
the point has been made.

Having "feely talks" with one another.
"Have you ever felt like
you needed to cry?"

Providing a shoulder to cry on.

(Ms.)cellaneous

Wanting minute details of an event
so she can spend hours dissecting
it for hidden meanings.

Waiting until standing at her car door
to get her keys out of her purse.

Being able to imagine owning things that
belong to other people, such as a man-
sion, the crown jewels, or Mel Gibson.

Talking on the phone and applying
makeup in her rearview
mirror while driving.

Demanding to be treated equally,
except when the check arrives.

Losing her footing by being given
the role of honored guest on
a weekend getaway.

Obsessing over Brad Pitt.

Deer hunting is Bambi killing.

Turning the heater on in the summer.

Finding hidden meanings
and subtle signals in thin air.

• GIRL ACTIVITIES •

1. Waxing
2. Manicuring
3. Exfoliating
4. Moisturizing
5. Pedicuring
6. Masking
7. Plucking
8. Hemming
9. Gossiping
10. Foiling

Looking down on fellow female
coworkers striving to be successful.

Being powerless to open
any jar in the kitchen.

Cleaning her house before
the cleaning lady arrives.

Watching foreign films with subtitles.

Keeping a diary.

Whatever is said has at least two interpretations.

Rubbing the lamp, then being surprised when the genie comes out.

Calling it "our house," all the while knowing it's really "her house."

Leaving the house carrying a waste-basket, drugstore, makeup counter, and ATM machine all rolled up into what she affection-ately calls a purse.

Measuring time by the length of her cigarette: "Oh, it will take me about two cigarettes to get ready."

Calling the colors blue, green, and orange, respectively, aqua, hunter, and sunset.

Understanding the difference between cream, ecru, eggshell, and off-white.

Hearing the response "yes" or "no" and still requiring an explanation.

Never, ever giving up; and never, under any circumstances, facing facts.

Changing the TV channel only after fully understanding what she is leaving.

Knowing that a recipe created by a master chef can always be improved.

Knowing the true art of conversation is to only say the right thing at the right time, but still saying the wrong thing that should have been left unsaid.

· GIRL STUFF ·

1. Doilies
2. Breast petals
3. Glue gun
4. Door wreaths
5. Curling irons
6. Salad spinner
7. Candles
8. Water bottle
9. Coasters
10. TopsyTail

Banging her head against
the glass ceiling.

Taking golf lessons because
it's a good career move.

Working mother is a redundant phrase.

Refusing a simple answer to anything.

Actually dialing in her opinion after seeing a truck adorned with the bumper sticker, "How's my driving? "Call 1-800——".

Determining that she is the only person capable of properly changing her baby's diaper.

Booking passage on her mother's frequent guilt trips.

Claiming indecision is her way of showing flexibility.

Luxuriating in a bubble bath with a good book and a glass of wine, oblivious to the chaos outside the bathroom door.

Remaining calm is a sign that she just doesn't have all the facts.

Forging an unofficial (and often unappreciated) second career as a psychotherapist.

Knowing that inside of her is a thin
person struggling to get out.

Reading and understanding
her cat's facial expressions.

Keeping track of everyone else's
drink consumption.

Owning a post office box to
send credit card bills to.